The clatter of clogs in the early morning

In the wake of the knocker-up there would shortly come the growing clatter of clog-irons on the flagged and cobbled streets, as the mill workers hurried to work – big and little piecers, carders, doffers, spinners, tacklers and that most venerable of all mill operatives, the six-loom weaver.

On dark mornings the mills were ablaze with gas-light; regular crystal palaces they were. At one time hundreds of candles had provided the working light, but they had now given place to the brighter, slightly safer town gas.

When the mills were first lit by gas, so great was the novelty and so marvellous the spectacle that folks walked for miles just to gaze in admiration.

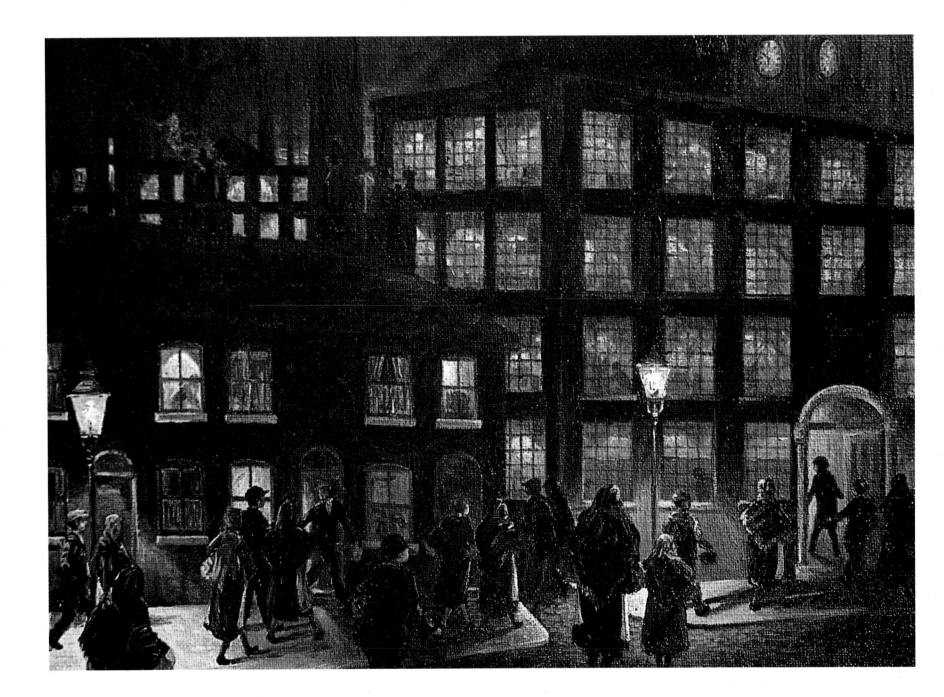

The clatter of clogs in the early morning

Fred Wilde

Foreword by Edward Woodward

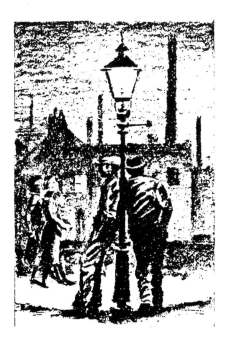

Collins
St James's Place, London
1982

William Collins Sons & Co Ltd
London · Glasgow · Sydney · Auckland
Toronto · Johannesburg

First published 1982

Reprinted 1983

© Fred Wilde

Designed by John & Griselda Lewis

Made and printed in Great Britain by
W. S. Cowell Ltd, Ipswich

British Library Cataloguing in Publication Data

Wilde, Fred
The clatter of clogs in the early morning
1. Greater Manchester (Metropolitan County –
Social life and custom – Pictorial works)
1. Title
942.7'3'0830222 DA690.M4

ISBN 0-00-216527-9

Foreword by Edward Woodward

Fred Wilde makes me laugh. Within five minutes of our first meeting I felt happy and full of joy; the pleasure of his company wrapped itself around me like a warm quilt on a raw day.

His paintings have the same effect, not only on me, but on all those lucky enough to own one. You don't just look at a Wilde picture: you devour it – you discover and re-discover, and the pleasure goes on and on. I am forever in the debt of Ken and Audrey Smith of the Stratford Gallery in Stratford-on-Avon, who six years ago introduced me to Fred's art.

He was born and brought up in Hyde, on the outskirts of Manchester, and lived for most of his childhood in the terrace house shown in his painting of 'The Lamp-lighter'. His father was a textile manager. Fred himself attended Hyde Art School as a boy, and as a young man went now and then to life classes at Manchester Municipal Art School. In due course he became a textile designer. This, and sixty odd years of painting in his spare time, is the only training he has ever had.

He paints what he knows and what he loves – the scenes of his childhood in the twenties and thirties – the closely-knit world of the cotton-mill workers, an environment in which poverty was offset by neighbourliness, and the lack of modern recreation was compensated for by simple home-devised pleasures. This was Fred's world and he presents this world to us with love and humour and with eloquent simplicity.

There is much love in this man Wilde, and much love in his work. I hope you enjoy his book. I think it's 'champion'.

Publication of this book about Lanca-
shire life by a Lancashire artist has been
made possible by the co-operation of the
Archive Project, Dunlop Ltd. In 1919
Dunlop built at Rochdale in Lancashire
what was to be for many years the largest
textile mill in Europe.

Contents

The artist is grateful to those whose names appear in italics above for permission to reproduce paintings in their possession. He is also deeply grateful to Kay Dotrice for the help and encouragement she has given him.

The knocker-up

Almost everyone in the village relied on cotton for a living, in one way or another. Most of them worked in t'mill, where the starting time was six o'clock of a morning.

The bed was always warm and comfortable at that time of day, and it was very difficult to get out of it, especially before cheap alarm clocks came on the market. So most folks employed t'knocker-up.

Owd 'Oppy Braithwaite, as our knocker-up was called, was willing, for a small payment, to 'get up before God' and clog round the village to 'get the day up'. His only company was the village bobby, one or two sleepy paper boys, and some homing tom-cats.

Our knocker-up was armed with an old two-piece fishing rod, to the end of which was attached an umbrella rib. With this sinister piece of equipment he could reach the highest bedroom window, on which he beat a sleep-shattering tattoo. He would not cease his drumming until his client had got out of bed and twitched the curtains at him in reply.

'Oppy Braithwaite started at the top of the village, furthest from t'mill, and worked his way down. For this service he received a penny a morning from each household. We never discovered who knocked up owd 'Oppy himself of a morning.

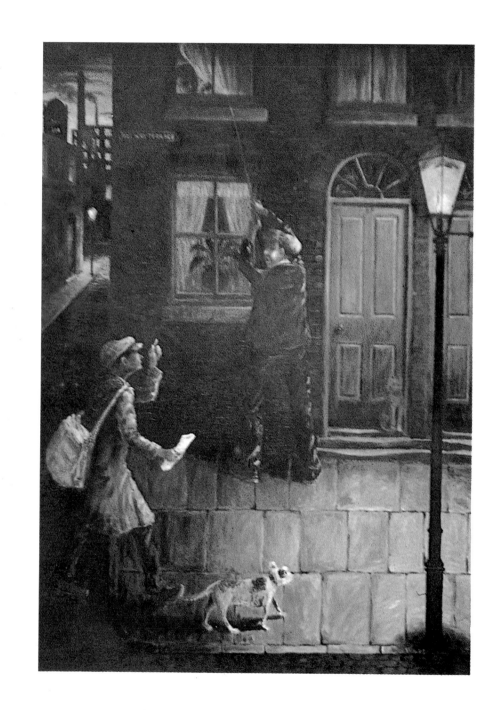

Monday morning wash-day

House work was highly organised. Each day had its allotted task. Wednesday was town-shopping day, when groceries were ordered for Friday delivery. Thursday was baking day; Tuesday was for ironing. And Monday was sacred to washing. It was sacrilege to perform this task on any other day.

Early in the morning the set-boiler fire in the back-kitchen had to be lit. It was a white-washed brick structure housing a kind of inverted cast-iron beehive into which were poured five or six gallons of cold water and some soap-parings. The fire was lit in the front, and the flames were drawn fiercely up and under the bulge of the bee-hive, quickly bringing the water to the boil.

The 'whites' were subjected to a vigorous boiling whilst being constantly stirred and prodded under the water by means of what was called a peggy-stick. After this treatment the articles were subjected to a work-out by a dolly-peg and rubbing board; then they were mangled and hung out to dry.

If things went according to plan all was well, but if it was a bad drying day the smell of damp clothes permeated the whole house, tempers became frayed, meals were of the resurrection variety, and steam seemed to linger everywhere.

I never did like Monday wash-day.

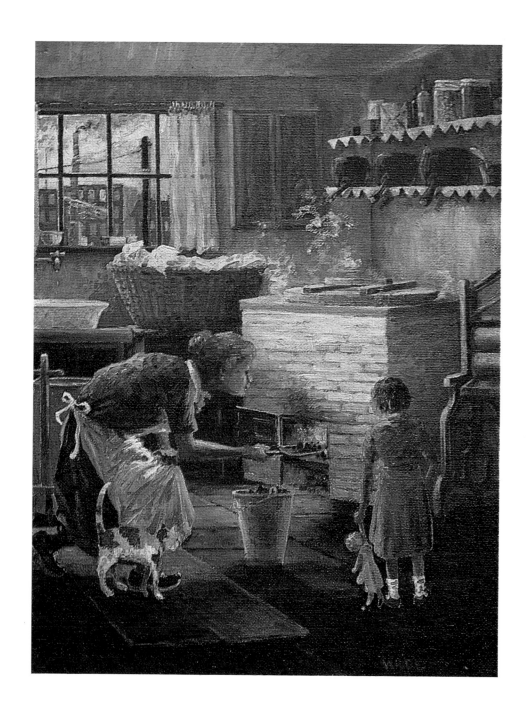

Little Dick

Our head teacher at St Mary's was getting on a bit. 'Past it,' many people said; 'Should have retired years ago'. Certainly he was short-tempered – and short on patience too. We boys didn't do much to help. He was a village institution, for he had taught his four R's – 'reading 'riting, 'rithmatic and righteousness' – to most of our Mums and Dads.

He had become a teacher in Queen Victoria's reign, and he was as straight-laced and pompous as Victorians were reputed to be. His name was Richard, but most people called him 'Little Dick' – though never to his face. He was strict on discipline, and backed up his teaching with a whippy bamboo cane. He had never been known to spoil a child by sparing the rod.

There was little talking or fooling when Little Dick was taking a class, but if some wretched lad uttered a whisper and was too frightened to own up, Little Dick would cane the whole class, innocent and guilty, girls and boys alike.

Besides his four R's he gave us a good grounding in the history and geography of the Empire. He was very proud of the fact that so much of the atlas, especially Africa, was coloured pink. His heroes – and ours – were Clive, Stanley, Cecil Rhodes, General Gordon and Kitchener of Khartoum.

Morally and physically he was an upright man – all sixty-four inches of him – a pillar of the Church, a sidesman and a parish councillor. He never doubted that God was an Englishman and middle-class.

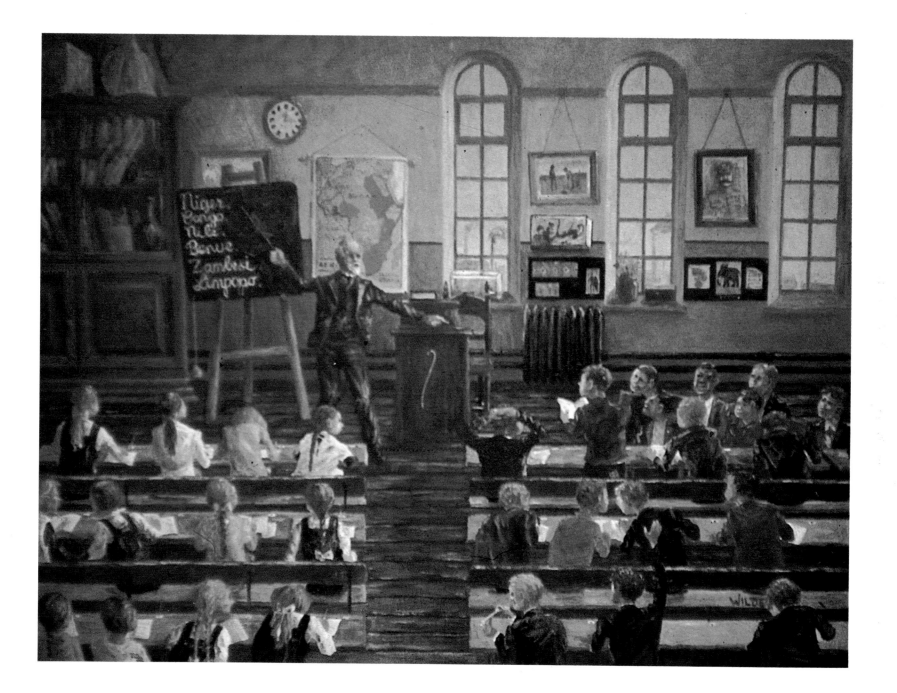

Potato-pie day

What with the week-end being over and it being wash-day, Monday was often a bit miserable. Thursday was my favourite day of the week. On other days I lingered to play on my way home from school; but never, never, on a Thursday, for Thursday was potato-pie day.

My Mum had a horror of shop-bought stuff. The phrase 'shop-bought', to her, meant rubbish. We were therefore fortunate in always having home-baked bread and home-made pies and cakes.

Being thrifty by nature as well as by necessity, my Mum used to put a potato-pie in the oven when she had got it hot for the bread. So Thursday being baking day was also potato-pie day. This superb dish was made from chopped meat, diced potatoes and carrots, with onions and that strange ingredient called flair. The top crust was thick, golden and crumbly-short, with rich brown gravy bubbling out of the slits.

The smell of it cooking was everywhere, and never failed to set the 'mouth-water' running. I can still remember the delicious taste of the third helping. Follow this with creamy rice pudding, and life has little more to offer!

With potato-pie went pickled red cabbage or beetroot and H.P. sauce in the familiar square bottle which gave many of us our introduction to the French language.

Can you wonder that I hurried home on a Thursday, potato-pie day?

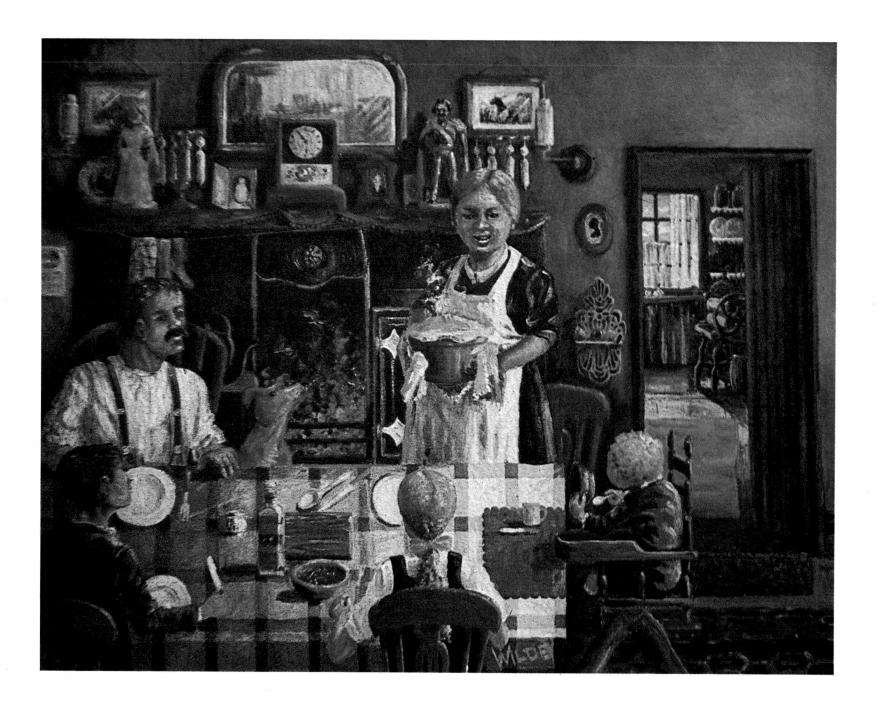

Donkey-stone day

On Friday morning 'the front' of our house had to be 'done', so that it looked nice for the week-end. Friday was known as 'donkey-stone day'.

'The front' consisted of the door steps and a surrounding area of pavement, which had to be swilled, partly dried and then stoned, which meant being rubbed over with a small hand-sized block of soft, reconstituted sandstone, either in white or various shades of yellow. Sometimes, if the housewife wanted to cut a dash, two colours were used.

The stones were usually got from t' rag-bone fella who came totting with his pony and cart. He traded them for old rags or empty jam jars. Often the trade-mark indented in our stone was a figure of a donkey; hence the term 'donkey-stone day'.

If during the 'doing' there was a chance of hearing a bit of gossip, so much the better; but woe betide the careless or lazy housewife who failed to 'do' her front. This was a crime against respectability, almost as bad as having dirty curtains in the window.

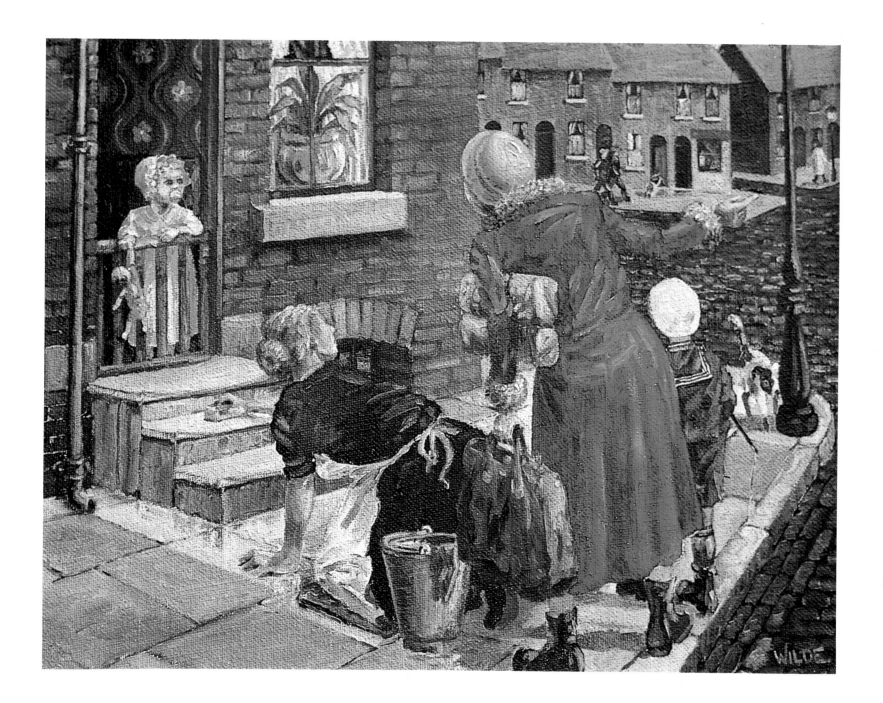

Coming home from t'mill

There can't have been many more noisy places than a weaving shed in full cry, with the healds clacking up and down, lifting and lowering the warp threads, the beaters packing the threads, and the picking-peg straps side-swiping the steel-nosed shuttles back and forth to lay the weft.

So great was the noise that workers found it impossible to talk to one another in the ordinary way, no matter how loudly they shouted. They developed a silent lip-reading and hand-sign language, known as 'mee-mawing'.

Even the noisiest shift came to an end when the mill buzzer announced knocking-off time (half-past five on weekdays, twelve-thirty on Saturday). Every mill had its buzzer, to announce stridently the beginning and the ending of the working day and the beginning and end of the dinner hour. They ruled people's lives. You could hear them blowing, basso or falsetto, shrill or gruff, varying by minutes according to the vagaries of the fire-man's watch.

The end-of-shift buzzer soon gave way to another sound, the clatter of clog-iron on the flags and cobbles as the workers hurried home.

The men usually wore heavy pit-clogs and overalls. The phrase 'He wears a suit to work' denoted someone who was on the way up in t'mill. The uniform of the lasses was a large white calico apron, a woollen shawl that served as overcoat, head-covering and gloves, and neat clogs with a shiny brass clasp at the instep and bright nails all round the sole. The turned-up toe was pointed and decorated with a brass toe-cap. The outfit was completed with a basket which carried dinner pots, reed-hook, scissors, etc.

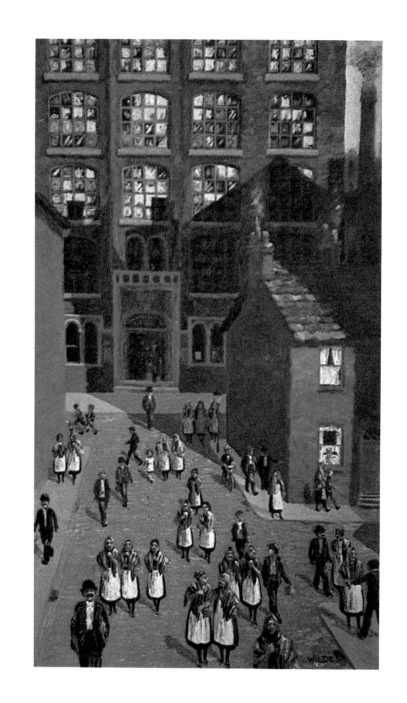

The corner shop

Many of the women stopped on their way home from work either at the chippy or th'owd corner shop, to get something for tea. The corner shop sold almost everything needed for day-to-day living – bacon, ham, paraffin, treacle, baby's gripe water – the lot!

Service was personal and helpful, and shoppers' minds could be changed without the ditherer being made to feel a nuisance. News and gossip was added, as a bonus.

Besides the daily necessities a few more substantial items were available, such as zinc baths (Friday night was bath night), wire-netting, and oil-cloth for the floor. This last was not to be confused with proper linoleum; it was no more than cheap printed roofing felt, which was laid over the uneven, damp flags in the back-kitchen, under the coconut matting. In the popular parquet and draught-board patterns it could also be bought, as could the tin baths, at Chas' Ackroyd's shop down the road.

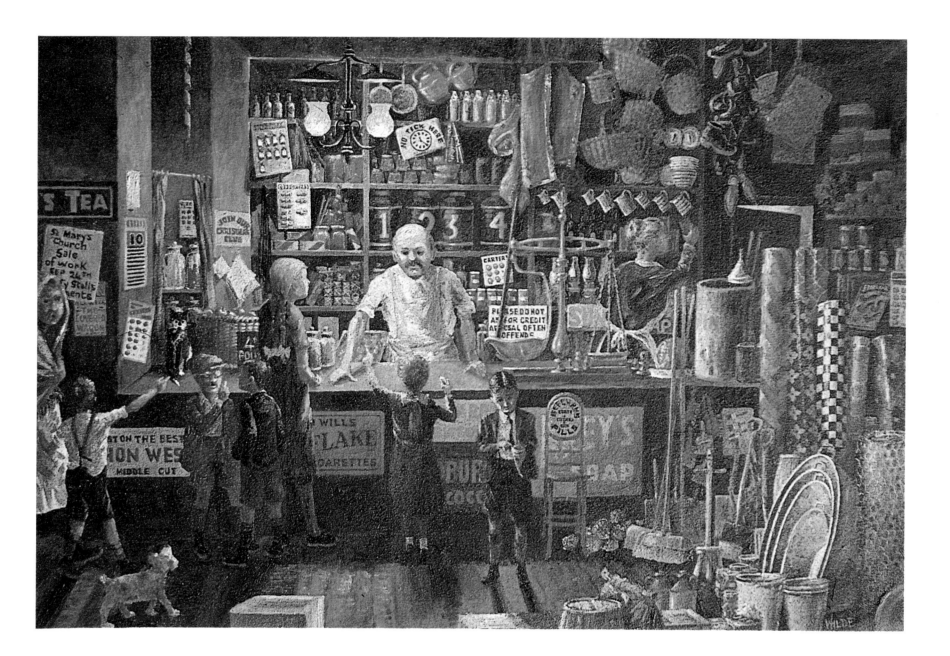

The furnishing ironmonger's

Chas' Ackroyd said he kept a pot-and-pan shop, but it was officially known as a Furnishing Ironmonger's.

In addition to oil-cloth, he sold mangles (not wringers), galvanised peggy-tubs, dolly-pegs (like little thin men with very short legs and out-stretched arms), ladeing and degging cans and corrugated rubbing boards. Later these were turned into more or less musical instruments by Lonnie Donegan and the skiffle boys, remember?

Next door was the Hatter's Rest, known as Th'atter's. The name marked the fact that the next town was one of the greatest hat-making centres of the world. Trilbies, bowlers (pot-'ats), homburgs and flamboyant ten-gallon stetsons were planked there and exported to the four corners.

Th'atters had a news-room, a legacy from the days of mass illiteracy, when items of interest would be read out aloud to the assembled non-readers.

And the women still cleaned the upstairs windows in the time-honoured fashion, sitting on the sill, outside the window, with their bottoms to the street.

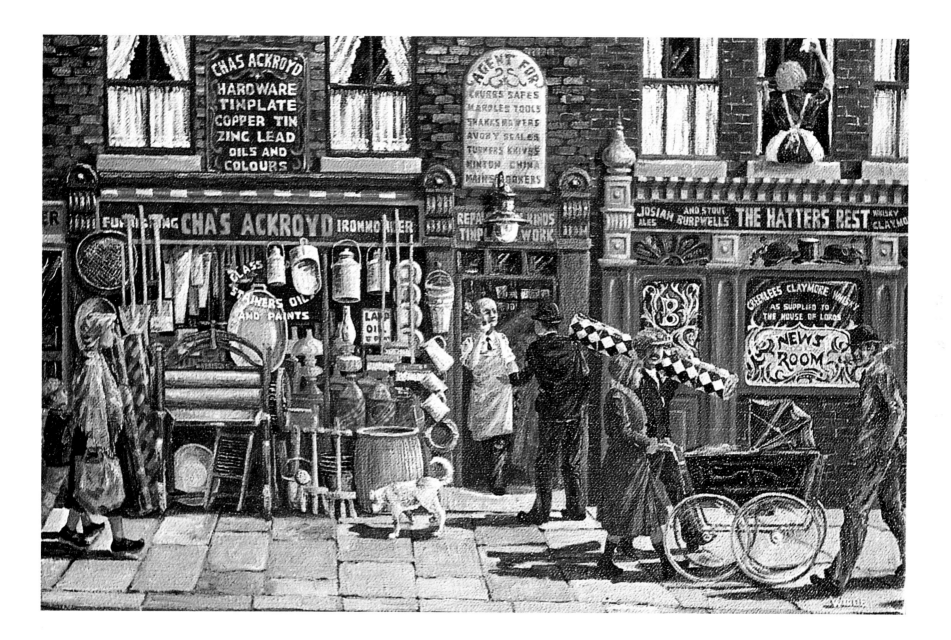

Market day in Milltown

Most folks did their ordinary shopping locally, getting credit until pay-day if their standing was good. But on Saturdays it was market day in nearby Milltown. Everyone went there to get bargains.

It was one of my great joys to be taken there at the week-end. Most of the folks who came to stand and sell stuff were characters. Larger than life, generally a bit outrageous, they dressed loudly and shouted, making people laugh with their ready wit and patter.

There was Curtain Mary, Pot Alice, Reg' the Veg', the General, who owned and provided the motive power for Buffalo Bill's Rough Riders, Mat Woodhead with his pea-soup tent (Tripe and Cow-heel a speciality), and many others including a very large coloured man (and there weren't so many around then). He wore a tall shiner and a red-and-white striped blazer. He claimed royal descent – my Dad called him 'the Black Prince'. His particular line was that he possessed a secret tribal recipe for making a marvellous tooth powder, which, if used regularly, would prevent dental decay, making molars last for ever.

Like many other coloured people he had magnificent choppers, shiny-white and large. Every now and then he would lean towards his audience and, pointing at his bared teeth, would declaim in basso-profundo: 'An' dese teef ah mah own TEEF!'

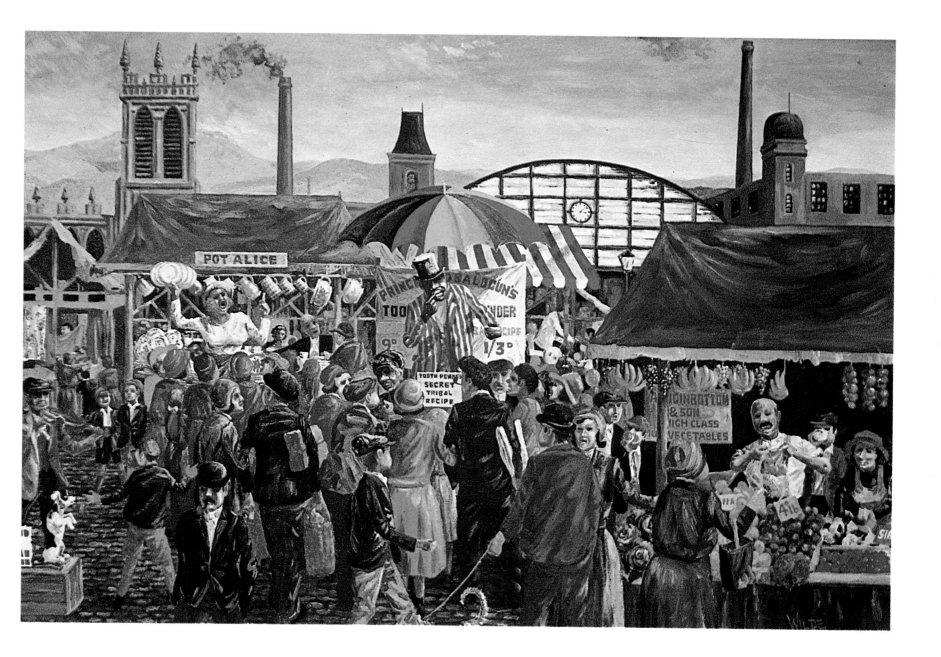

Buffalo Bill's Rough Riders

One of the joys of the market, to a boy, was the bright little one-man-powered roundabout which stood at the top of the square near the Bank. Round the edge of the canopy it bore, lettered in red on gold, the thrilling words BUFFALO BILL'S ROUGH RIDERS. It was hardly a rough ride, however, for the elegant mounts never progressed at more than a steady trot. Still, it only cost a penny a go; and you got a long ride, especially if you were recognized as a regular.

The 'General' stood in the middle, sweating as he slowly turned a large wheel which had a protruding handle, just like the mangle at home. He would urge on customers with raucous cries of 'Any more for the pony express?' or 'Who's for the Wild West?' or 'Come along, you desperadoes!'

He must have made a very precarious living, and he certainly earned every penny of it.

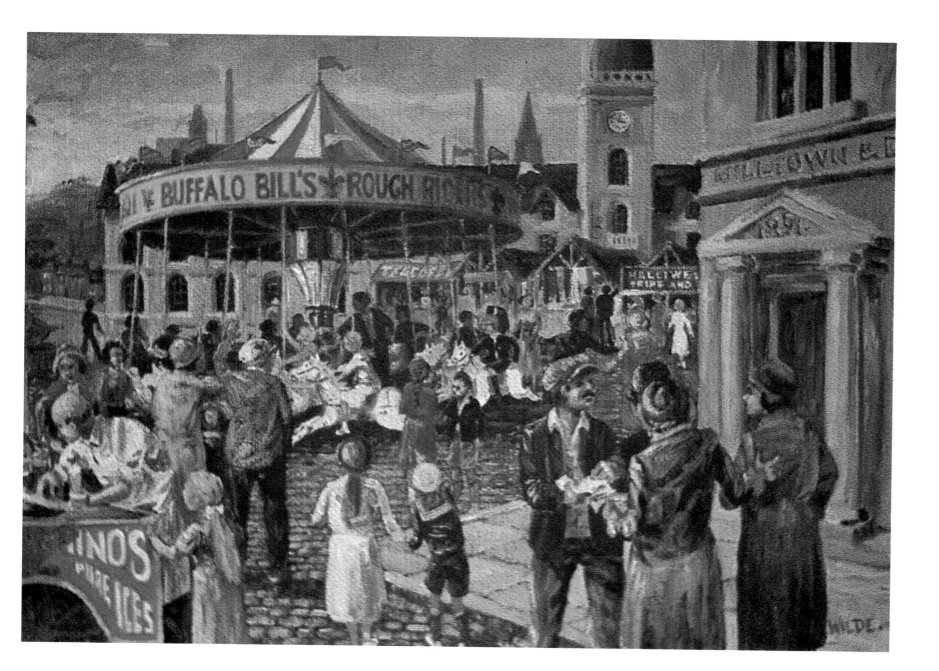

The lamp-lighter

We lived a mile away from school in a small row of two-up two-down houses. Ours was the end one, and it had a slated gable which rattled alarmingly when the winds shrieked down from the Pennines. I can still recall nights of turbulent darkness full of unease as the house rattled its slates.

We were fortunate enough to have a lamp before our front door. Willie Woodhead's Dad was the lamp-lighter and he came round every evening about dusk, with his long lamp-lighting stick.

At the top of this stick there burned a small acetylene flame made by dripping water on to carbide of calcium. I knew this because I had a bike lamp which worked the same way.

He would push his stick up through the hinged window in the bottom of the lamp, turning on the gas at the same time. The gas mantle would go 'plop', and immediately there was a lovely pool of soft, golden light on the pavement.

It was grand to play Rally-o, or Rounders, with the Den marked out in chalk under our lamp.

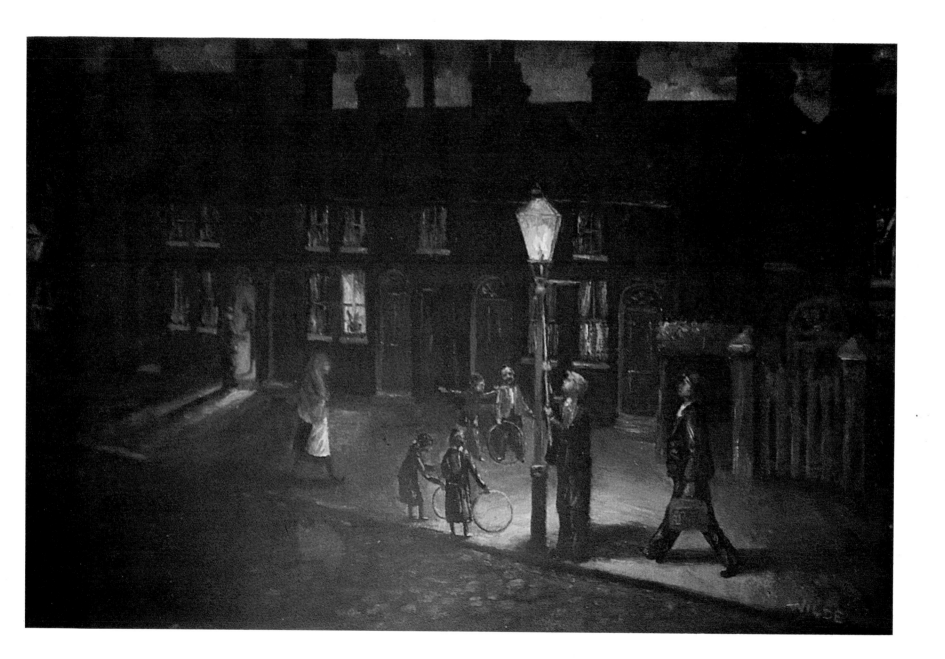

Saturday night market

At night the market came into its magic own. Then the hissing naphtha flares were pumped and hung high on the stalls, seeming to make a tent of the night by shutting out the dark, and giving the whole bustling scene an air of mystery.

In the flickering light the tripe-and-black-pudding stalls, the ice-cream carts, the brandy-snap and cough-candy stalls, the dress materials and reach-me-down clothes, took on a romantic air they never had in the light of day.

That was the best time to listen to Harry Gould as he wove his web of words round his merchandise of jewellery, watches and clocks. There was always a crowd round Harry's stall, for his wit was as reliable as the things he had to sell. He had 'stood' in Milltown market since my Dad was a lad, and had become a legend for honest dealing.

If you bought a watch or clock from him, and it went wrong, you took it back and there was no question. His two sons helped him on the stall with repairs, but they hadn't got Harry's gift of the gab. When I was twenty-one my Dad bought me a Waltham hunter watch and a double-Albert chain from Harry – which I still have.

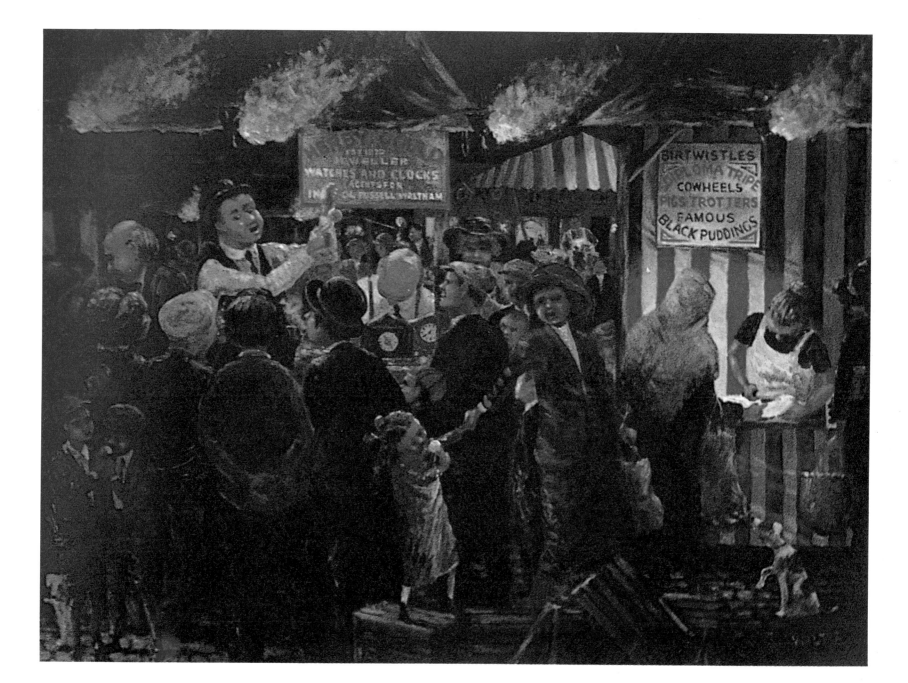

Going to choir practice

Going to the local market or making an excursion to the big city was something we did on a Saturday. Sunday was considered to be 'a day of rest'.

Not for me, though! My Sundays were busier than weekdays. Not only did I have to attend Sunday-school in the morning and in the afternoon, but I had to go to church also in the morning – after Sunday-school – and in the evening, for I was a choir-boy.

There was choir practice on Thursday evenings, and in order to attend we had to go down a dark and lonely lane called Dam-side. Here the trees met overhead to form a dark tunnel. It was a terrifying place, with, needless to say, a very sinister reputation.

Even on light evenings it had an air of mystery, but on dark nights it was far too frightening to enter alone, and I used to wait for the support of some of my fellow choristers before venturing into the dark throat of the trees. Even then we daren't advance without a flash-lamp – a Lucas bike lamp with a flat wick and green and red windows port and starboard – or perhaps just a cut-down candle stuck in the bottom of a glass jam-jar.

Even with the support of our lamp we all walked quickly up the middle of the lane, trying not to notice the shifting shadows of 'things' to right and left.

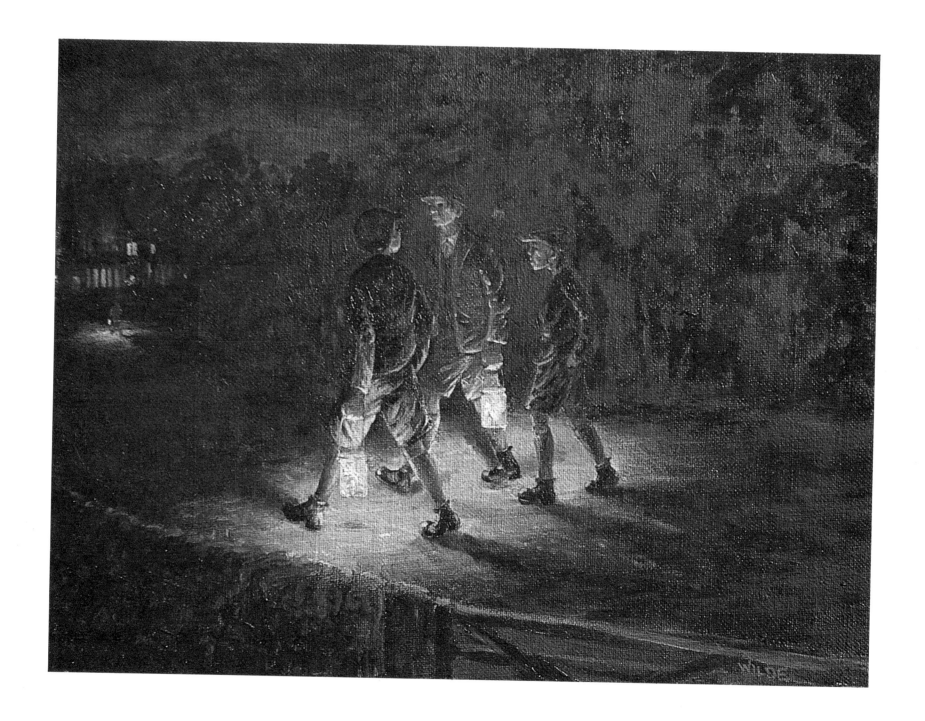

Owd Bottleneck and Handy Harry

If you were late for choir practice, through having to wait for company before venturing into Dam-side, 'owd Bottleneck' Hopkins, the organist, would be furious and threaten to tell your Mum. He regarded his practices as sacred.

For practice the choir sat in the front two rows of pews, with owd Bottleneck sitting at a small foot-pedalled harmonium, which came from Philadelphia and had red felt decoration on the keyboard. He used a lot of sarcastic phrases such as 'You boy, stop that yawning. If you learnt to breathe properly you'd never yawn', or 'Open your mouth wide, boy, and let the sound out. You're shouting "Hosannah", not saying "Don't waken the baby"'.

If you whispered or sniggered during service, you would get a clip on the ear from the leading tenor, Mr Schofield. His nick-name was Handy Harry, and he did the clipping quietly through one of the carved holes in the back of the choir stall. And a very painful clip it was, for Handy Harry had an artificial hand, made of hard wood, in a brown kid glove.

Going home after practice was quite different from the walk down Dam-side, for you weren't in a hurry, and you could go round the long way, up Calico Street and down Alexandra Road, with street lamps all the way. Those street lamps made all the difference between fear and fun.

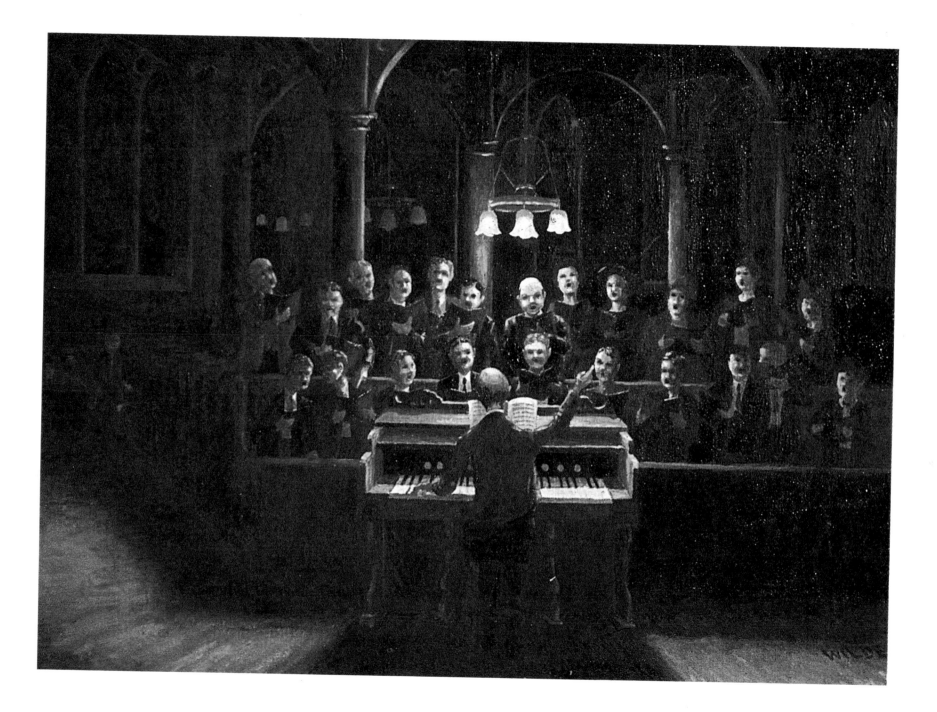

The sale of work

Most of our entertainments were pretty humdrum and home-made, but they suited us because in those days there were few 'canned' amusements against which we could make comparisons.

A Sale of Work doesn't seem a very exciting event nowadays, but the effort put into this used to keep a lot of people busy for a long time. Teddy bears and soft toys had to be made; tea-cosies, 'Duchesse' sets and cushion covers sewn. Garments had to be knitted; wooden toys had to be fret-worked; pickles, jams and chutney had to be prepared; and on the day bread and cakes and pies had to be baked.

Mr Lowson, the parson, always opened the Sale of Work, and he usually forgot he wasn't delivering a sermon and went on so long that folks got impatient. 'He *is* going on a bit,' they'd mutter, all eagerness to start buying or to have 'Madame Za-Za' (whose real name was Mrs Richardson) tell their fortunes. 'Is it to be tea-leaves, dear? Or crystal, or palm, or cards?'

One of the favourite confections made for the Sale of Work was known as 'Mother-to-be-cake'. It was traditionally made by expectant mothers. It was rich in fruit and sugar, and generally baked in a large, flat tin. The idea was that it would keep moist for a long time so that husband and family would have 'something to cut at' whilst Mum was lying-in.

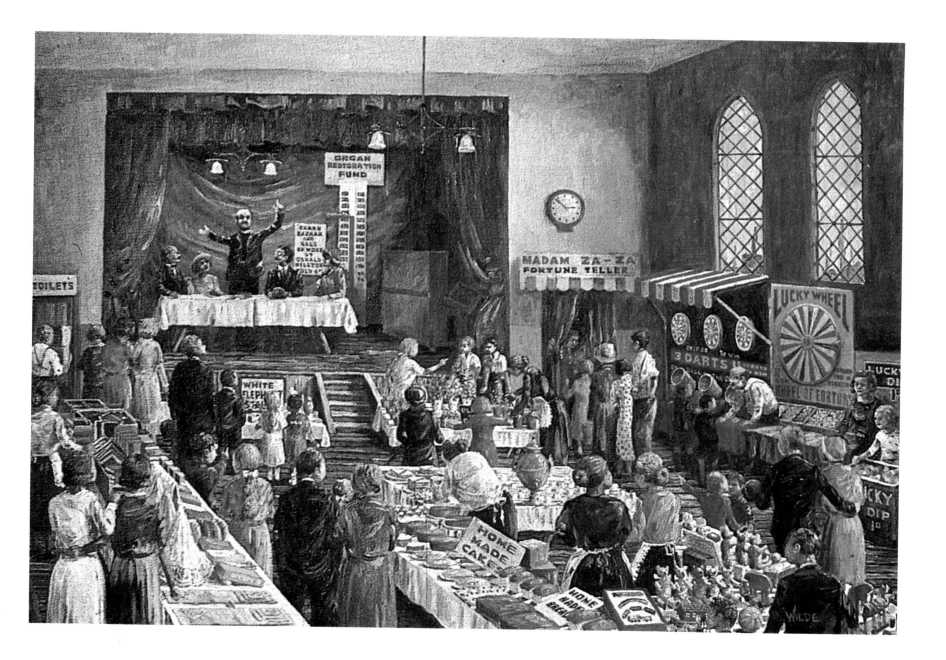

The village hop

Our class-rooms in the school were divided by moveable partitions which ran in narrow tram-lines set among the knots and nail heads in the splintery floor. When we had a 'do' or dance these screens were folded back to make one large room.

'Grand Dances', as they were advertised, or 'hops' as we called them, were very popular. The music was provided by Tom Harrison and Mr Hopkins, owd Bottleneck the choir master, who later tried to teach me to play the piano.

At these hops it was customary for the girls to line one side of the room, the boys the other. Only courting couples ever sat together. It usually required a 'dare' from some other boy to summon up the courage to face the ordeal of crossing the room to request a dance. I can still recall the magic of dancing to 'When you and I were seventeen.'

A ticket for a hop cost one-and-sixpence, including refreshments, which were sandwiches cut up into fancy shapes by volunteer Mums, who also 'mashed' tea in great copper urns at the back of the room. The vicar, Mr Lowson, also did his bit, helping to keep the young people 'off the street' by smiling toothily at everyone as he sprinkled French chalk and candle grease over the splintery floor.

Over it all there hung a smell of brimstone from the boiler furnace in the cellar; but that never detracted from the enjoyment of the hop.

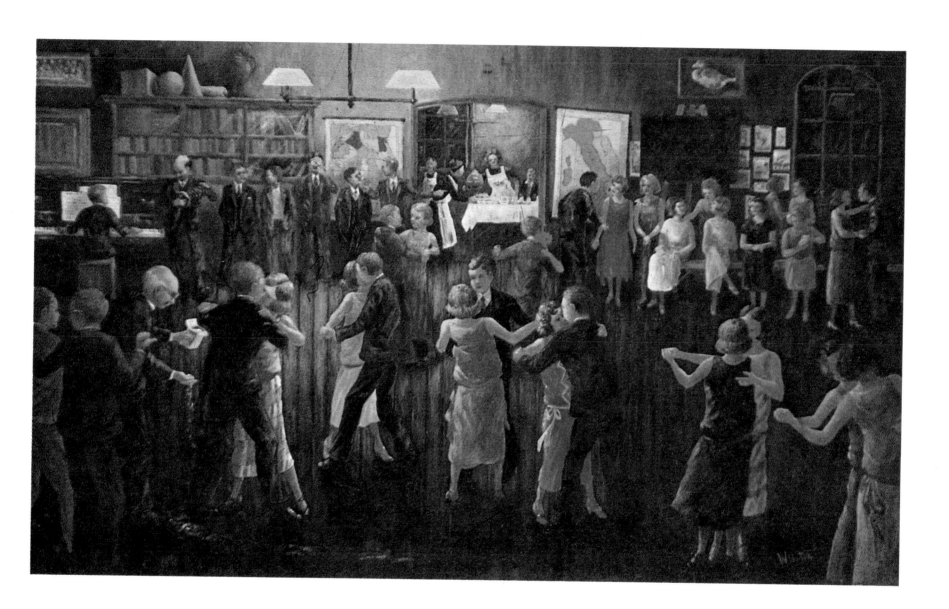

The recitation

Both Sunday-school and church were always short of money, and we had to join in all sorts of money-making efforts – bun-fights, 'tatie-pie suppers (bring your own knife and fork), whist drives and concerts.

The concerts were surprisingly well patronized, in spite of the fact that nearly always the same artistes took part. There was Miss Jackson's dancing class, tap and ballet, with speciality dances by Miss Jackson herself. There was Handy Harry Schofield, with his artificial hand, singing in a throaty tenor 'Come into the garden, Maud' or 'I am the Bandolero'. And there was Handy Harry's friend from the choir, Mr 'Juddy' Newton, whose voice came from down in his boots to render 'My Old Shako' and 'Drinking'.

Then there was Miss Ollerenshaw, who sang alto in the choir, but she preferred to do monologues with morals to them, such as 'You never miss the water till the well runs dry', or 'The mill can never grind with the water that is passed'. Miss Ollerenshaw had a big chest, and my Dad often referred to her favourably as 'a fine figure of a woman'.

Egged on by my Mum I crept up on the stage to recite 'The Burial of Sir John Moore' or 'The Inchcape Rock'. I shall never forget the sense of isolation, of being alone on that stage, but as the words came I began to make pictures of them in my mind, and the audience ceased to matter. It was my English teacher, Mr Critchley, who taught me that trick, and a marvellous cure for shyness it was.

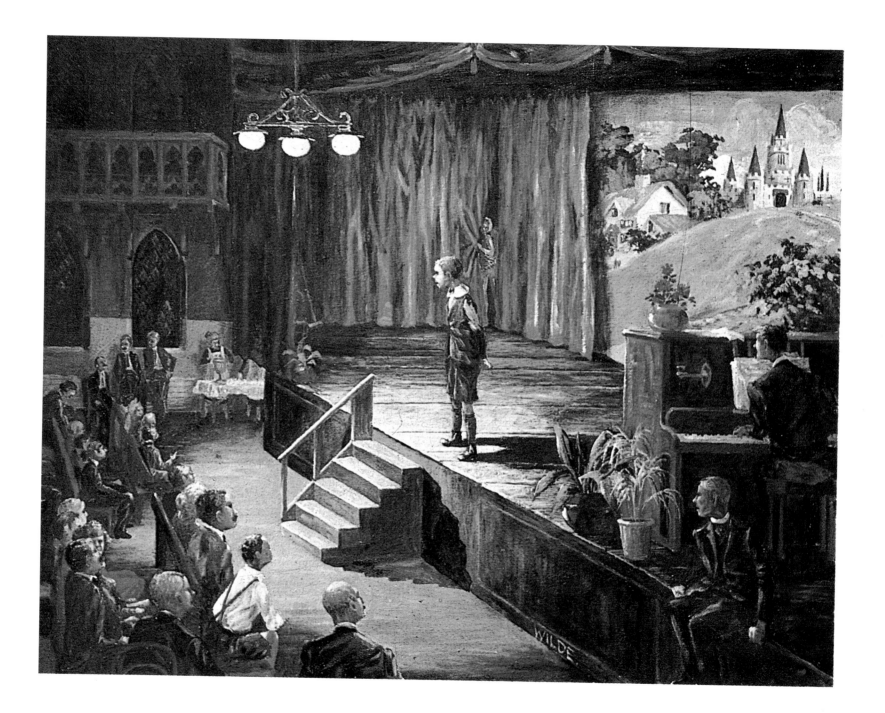

Whitsuntide procession

One of the big events in the church's year was Whitsuntide, when most of the people who went to St Mary's, in common with all the other churches in the neighbourhood, would turn out to 'walk'.

Banners were carried and there were bands, Boys Brigades, Scout and Wolf-cub Troops, Girl Guides, and a general air of jollification.

As many folks who could afford it wore new clothes. If they could not afford them for themselves, at least they bought them for the children. Juniors would walk round showing off their new Whit clothes, and their elders would put coppers in their pockets. The girls mostly had white dresses, and the older ones would be allowed to carry the banner ribbons.

We always had the Milltown Prize Band to lead our procession. The bandsmen wore maroon and gold uniforms and Billy Ogden's Dad used to swank in front twirling his decorated stick.

We walked all round the village, stopping here and there to sing hymns, like at Hall-top cross roads, Mr Turner's house, the square in front of the Lancashire Cheese pub, and at Hickens's Lodge.

In the afternoon we had a field day, with free lemonade, sweets and a bun. There were side-shows and races; three-legged, sprint, egg-and-spoon and wheelbarrow. With prizes!

The field day was generally at Mr Hickens's farm, because he was a sidesman and Sunday-school Superintendent. You had to watch out for cow-pats when you played rounders, or cricket, or ran in the races.

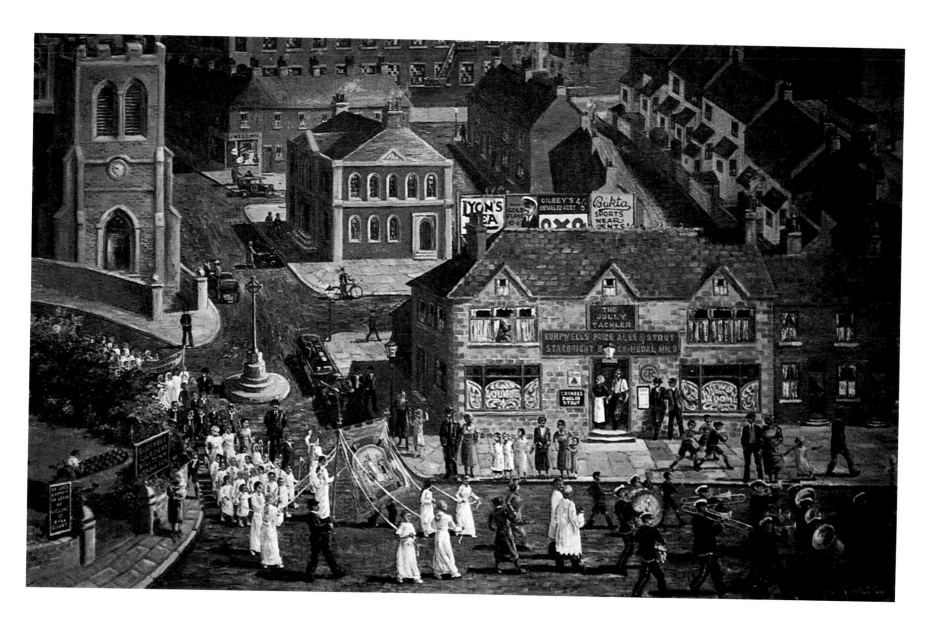

Crowning the Rose Queen

Another important day in the village was the crowning of the Rose Queen. Again this took place on Hickens's fields, and Mr Hickens himself did the organizing.

One of the big girls, like Nellie Schofield or Annie Alice Webster, would be chosen for the Queen, and the rest of them would be attendants. All the attendants thought that they should have been chosen to be Queen and hoped that next year it would be their turn.

Mrs Hickens did the crowning. She and her daughter Minnie were a bit stuck-up, but they had reason to be, for they had plenty of brass. For these occasions they wore their bit-o'-fox furs, which had proper feet and tails and staring glass eyes.

The Morris dancers and all of us in the Boys Brigade were there, and the procession was led by the petal scatterers. One year the petal scatterers were Mary Willshaw and little Annie Webb. They had never been entrusted with such a responsible job before, and they were filled with a great sense of their own importance. Like my Dad said: 'they didn't know whether it was Thursday or Christmas'. They were in a little world of their own; and in spite of many rehearsals they forgot to lead the way up the red-carpeted steps to the throne. Mr Hickens had quite a job to get them back on course again. Everyone except Mr and Mrs Hickens thought this was a great joke.

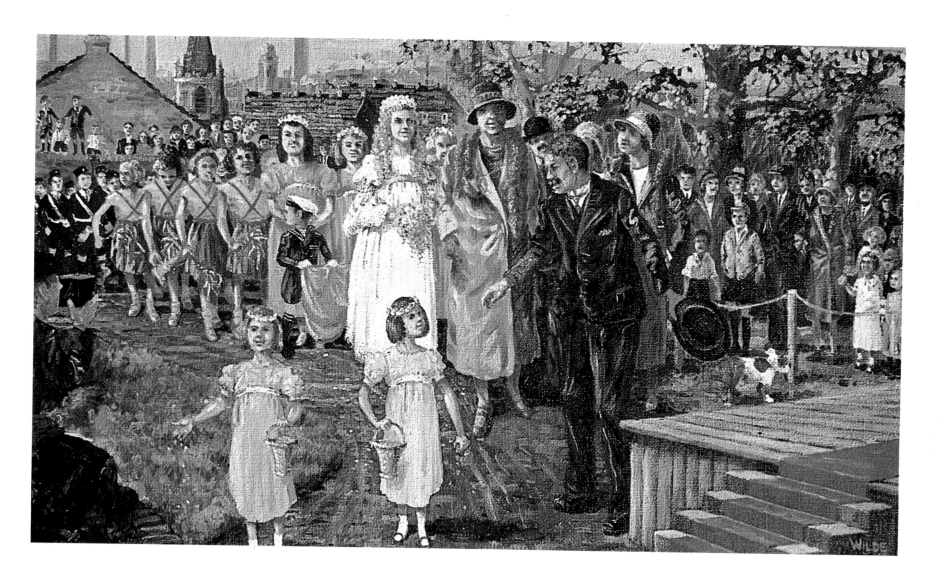

Bright lights and poached egg

Four or five times a year we made trips to the big city some ten miles away. It was a bewildering, thrilling place of bustle, bright lights, jostling crowds, great walk-round department stores, fairyland toy-shops, brash picture palaces and cafés.

These visits involved two tram-cars, the first one of which we caught outside Milltown town-hall. The ten-mile journey could take up to two hours, for we had to change at Hattertown.

The trams not only took us but shook us. My Dad said they were like spaniels that wagged their tails with the whole of their bodies.

In the trams were advertisements for things like Hudson's soap and Carter's little liver pills. There were two notices which have always stuck in my mind. They were always together, one above the other on the driver's glass door. The top one sternly ordered DO NOT SPIT; the lower one said USE THE SHIP CANAL.

One of the city treats we eagerly looked forward to (my Mum feeling as she did about 'shop-bought') was tea in a café. We always went to the same modest establishment and I always had the same meal; poached egg on toast. I could never be persuaded to have anything different. I loved this simple dish, the eating of which became something of a ritual. Never must a single drop of yellow yolk be allowed to fall upon the plate; it had to be taken up by clever cutting before all the toast was eaten.

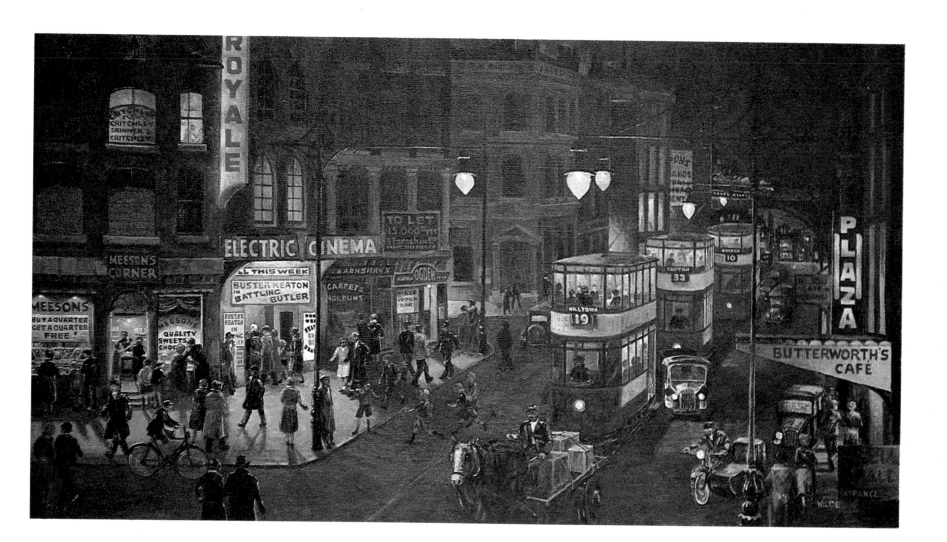

Coming out of the pictures

Now and again we went to one of the big city picture palaces, a rare treat! To see Buster Keaton, Nazimova, Mary Pickford, Charlie Chaplin, or my Mum's favourite, Emil Jannings.

Those city palaces were much more posh than our local laugh-and-scratch cinemas, the Scala and the Star. Often they had a small orchestra, not just a piano, to supply the sad, galloping, exciting, or frightening music the film action called for.

The Hollywood dream merchants were so clever in the making of their shadowy, escapist worlds that even after the film was ended its celluloid episodes seemed more real than the world we lived in. Films like *The Great Train Robbery*, *The Covered Wagon*, and *Trader Horn* with Harry Carey ('Blood brother to West African cannibals at eighteen . . .' !)– I saw that film eight times! – are never to be forgotten.

When we came out of the cinema it was usually dark and the gas lamps were lit, throwing their soft, golden patches of light on to the pavement and cobbles. Only the pubs and the chippies would still be open, and their bright windows added to the pattern of light and shadow.

The pubs were always full; they were the places of escape for the grown-ups, just as the cinemas were for us children. And there were always queues of customers outside the chippies, where the aroma was almost irresistible. My Uncle Harry used to say: 'Ther's nowt smells as good as a chippy i' full fry. If tha doesn'a feel hungry afore tha smells it, by gum! tha does after!'

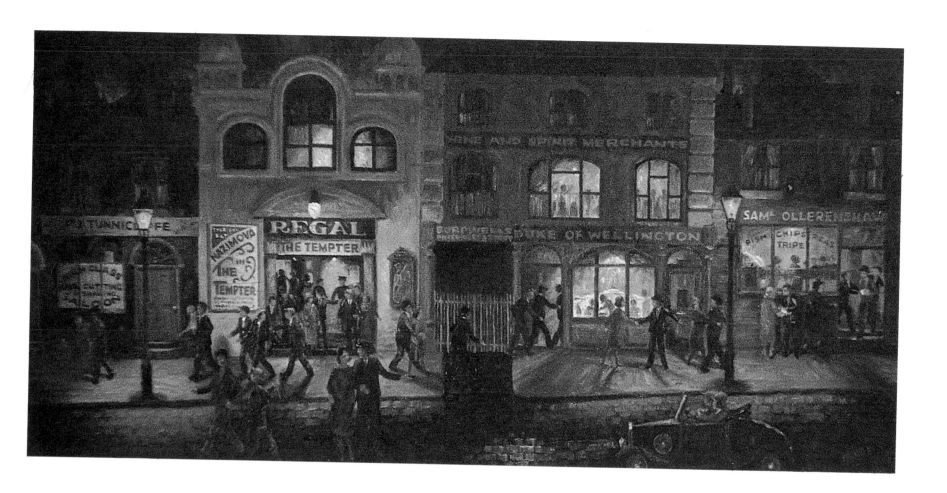

Wakes Week

Once a year, for seven days out of the three hundred and sixty-five, it was Wakes Week, when all the mills shut down, and Milltown became, for too brief a period, a smokeless zone.

All who could afford it went on holiday – generally to the seaside, for a paddle, a giggle and 'a breath of ozone'. 'You can do a lot of things by the seaside that you can't do at 'ome.'

Most folks paid a few bob a week, all though the year, into a 'diddle-em' club at the mill; and just before Wakes Week it was all drawn out. The shops had a busy time, as there was a lot of brass about. But most of it was saved to be spent at the seaside.

Under its high domed roof the railway station would be crowded with jostling, slightly bewildered holidaymakers. Not being seasoned travellers there was always an air of anxiety about them. 'Is this t' reet train fer Blackpool?' 'Do we 'ave fer t' change fer Morecambe?' 'Is this t' Third Class?' And the porters handed out snippets of information, grudgingly, to us country gobbins as we rushed about, dragging our luggage behind us, trying not to get lost.

Then at last the blowing of whistles, the 'All aboard', the waving of green flags, and the tummy-tingling excitement of it all – 'we're off on holiday!'

' 'ope it's t' reet train!'

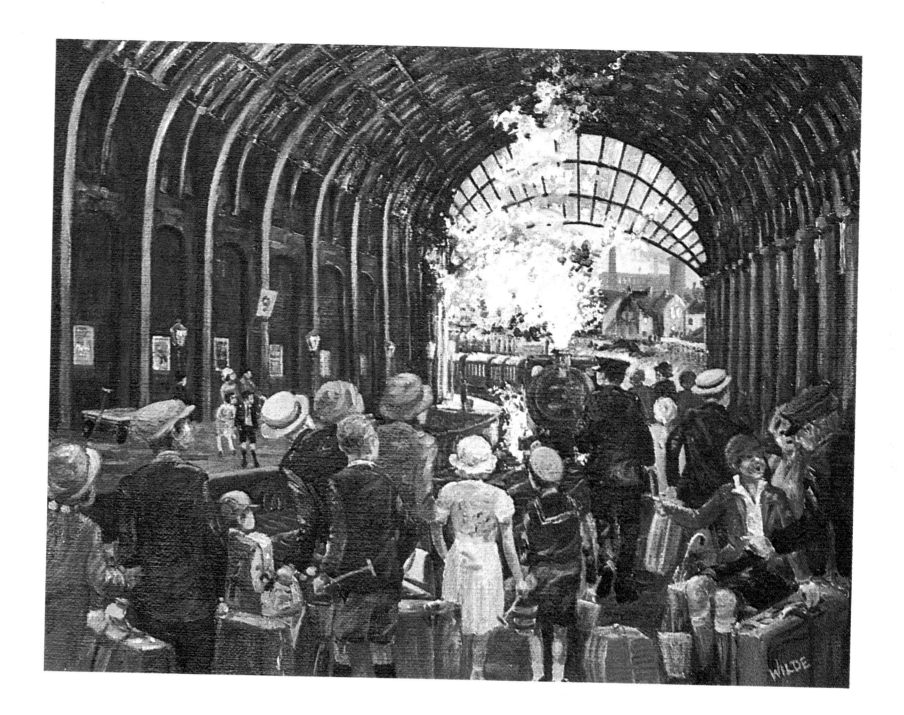

The little green engine

With steam blowing out from every rivet-hole, the little green London, Midland and Scottish Railway engine trailed a plume of smoke across the Pennine foothills, past mill towns that were still working (as their Wakes Week had not yet come round), through tunnels, over hollow-sounding bridges, alongside little brooks and green pastures, past barns and cricket fields and children sitting on stone walls. And all the time the carriage wheels sang their going song 'Going t' get there, tiddley-go, going t' get there, tiddley-go.'

You did your best to sit still, to behave, to read your comic, but it was very difficult when all the unfamiliar countryside was rushing past the window, the near objects going by in a blur, but the distant scenes more slowly and mysteriously. It was impossible to contain the pent-up thrill of it all.

'Don't play with the window-strap!' 'Stop writing on that dirty window! You'll be putting your finger in your mouth next!' 'There! What did I tell you? You've got a cinder in your eye: serve you right! Don't you dare lean out of that window again!' My Mum tried to speak 'proper', not like us boys.

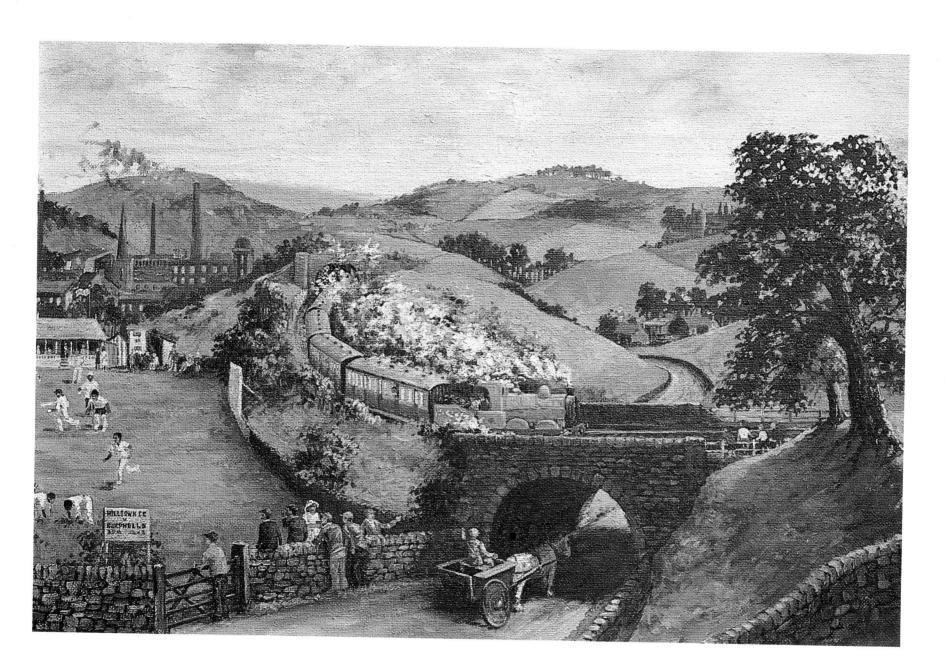

Crab fishing

It never seemed to rain at holiday time. The waves tumbled over themselves in their haste to reach the shore; the sea-gulls were raucous in their greeting; and the sand was all mine for digging. The pleasure boats filled up with the adventurous – 'Back in time for tea' – and some of the older boys strutted along the prom to investigate 'What the Butler saw'.

Of all the seaside delights my favourite was crab-fishing from the jetty. All that was needed was a long length of string with a stone sinker and some open mussels tied on to it at intervals, like the tailings on a kite. It was easy to find the mussels clinging to the pilings of the jetty.

When lowered into the water this tackle was deadly; the crabs couldn't resist the free meal, and it was thrilling to pull the string and feel them trying to sidle away with the bait. As they were hauled up they clung spread-legged to the bait and had to be very carefully removed by the legs furthest from the nippers.

Into the bucket they went; but at the end of the session they were all poured out on the jetty, and we watched them scrambling away, open-clawed and full of menace, to plop over the edge into the sea again.

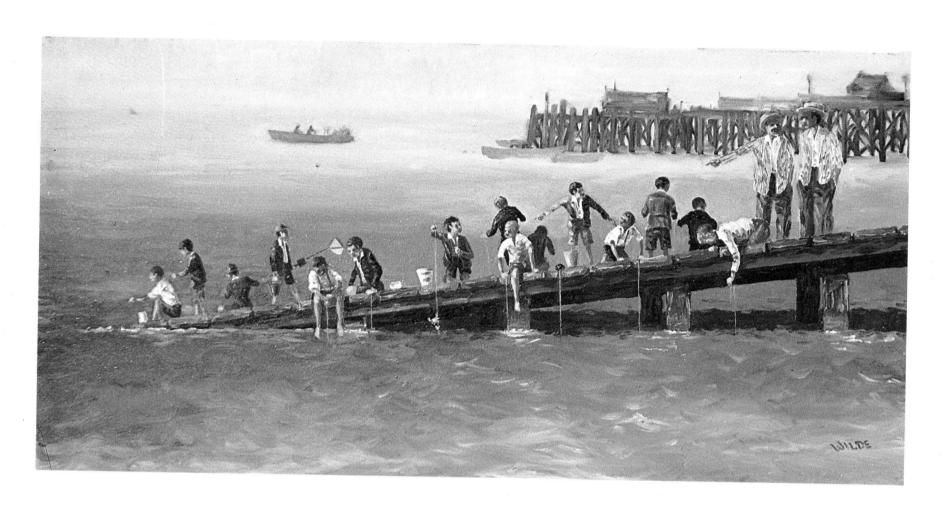

The fair on the Prom

Night was the best time to visit the fair at the top end of the prom. Darkness hid the tatty corners and the peeling paint. The steam organ music blared more brassily; the jostling crowds seemed more good-humoured, the barkers more persuasive, the Tattooed Lady more seductive.

The roundabouts took one on trips through a raucous fairyland; the helter-skelter spiralled one from the heavens; the rifles in the shooting gallery rattled and crackled. Then the great Ferris Wheel swung one's gondola up into the skies, with the stars sparkling above and the snake-wriggle reflections of the pier lights glittering in the black sea below.

The time to depart always came too soon. Tired and laden with hard-won spoils – coconuts, brandy-snaps and all kinds of trumpery trinkets, one turned for home reluctantly. 'Aw, Dad, please, just one more go!'

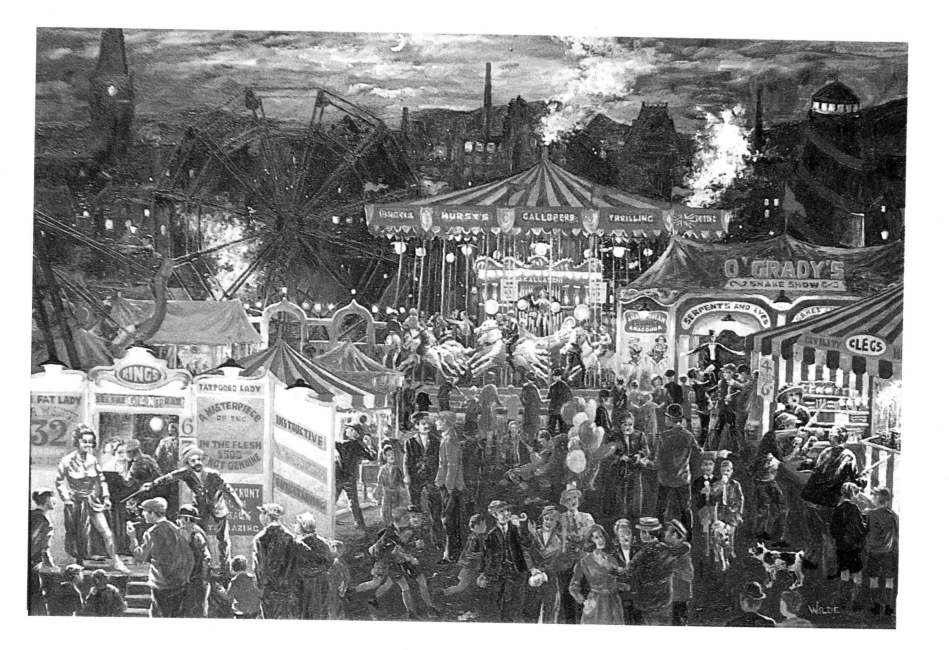

Wish you were here

Even on holiday, brief though it was, the work-a-day ties were never entirely broken.

We were expected to send post-cards to the stay-at-homes; nice views for respectable neighbours and relations; joke cards for more ribald acquaintances, and a few downright rude ones (but clever with it) for the regulars at the local and for work-mates.

This chore was necessary because all one's friends did the same. 'Let's see now, did Mrs Richardson send *us* one last year?'

'Oh! dear what can I say?' . . . 'The weather is not too bad, it rained yesterday, but not enough to keep us in; it's fine today though. We have good digs, clean; good food; having a lovely time; wish you were here.'

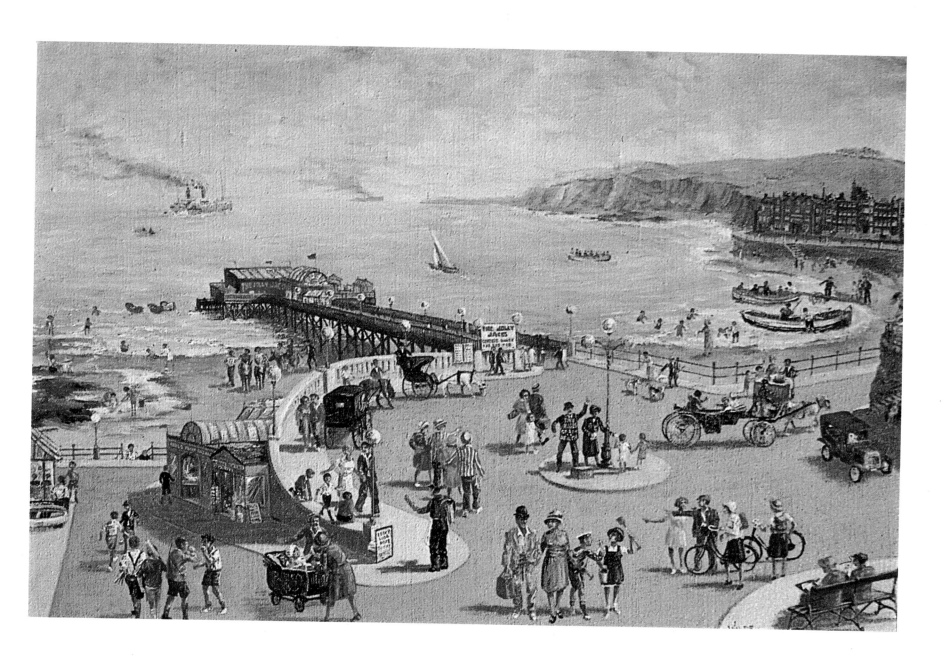

Guy, guy, hit him in the eye!

One of the other highlights of the year was the Fifth of November, when money and guys went up in smoke, but oh what special smoke!

Vesuviuses erupted, sparklers sparkled, Roman candles juggled balls of fire, and catherine wheels showered the night with stars. There were batteries of Chinese crackers, deafening explosions of thunder-flashes, and jumping rip-raps that would have woken Rip van Winkle. What a whizz-bang flash and crash it all was!

And then we had treacle-toffee, potatoes roasted in their jackets, and sticky parkin.

As we wheeled our guy from house to house in the evenings before Guy Fawkes Day this is the ditty we used to sing:

> We've come a cob-coalin', cob-coalin', cob-coalin',
> We've come a cob-coalin' for bonfire plot.
> Up a ladder, down a hole,
> Please to give us a cob of coal,
> Or else a box of matches.
>
> Guy, guy, guy, hit him in the eye,
> Hang him on a lamp-post and there let him die.

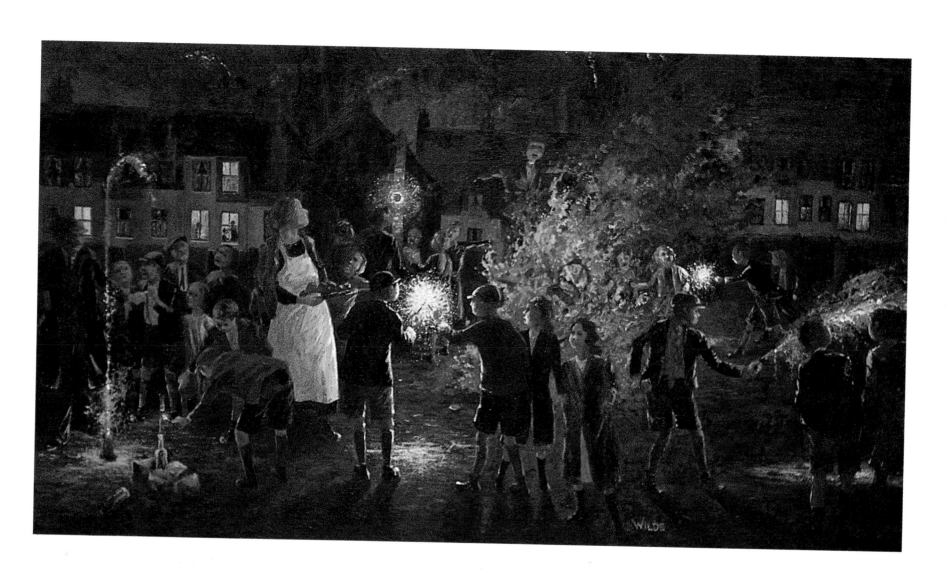

Dressing the tree

At last came Christmas, the 'can't-wait' time, the 'wonder-what-he'll-bring-me-if-I'm-good' time.

This was when the Parlour came into its own. Our day-to-day living was confined to the stone-flagged back-kitchen and living-kitchen; but for special occasions we had the Parlour. If the kitchen was the heart and hearth of the household, the Parlour was its shrine.

Here were all the family treasures: the acanthus-carved chiffonier, with its lead-cut mirrors; the Coalport and Minton; the black marble clock; the fairings and Staffordshire figures; the marble-chip flowers under glass domes; the brightly polished brass fender and fire-irons; the black horse-hair-stuffed suite (agony to the backs of bare knees!), and that instrument of torture, the upright iron piano.

At Christmas the Parlour was transformed by holly and mistletoe, tinsel, stars and home-made paper-chains. As he always did, Dad wrote 'A Merry Christmas' in soap on the mirror of the chiffonier.

The centre of everything was the Tree, from a Welsh hillside, one of many, but now our own chosen, standing in all its pagan mystery. Crowned with the figure of a fairy, decked in baubles and silver chains, gold tinsel and chocolates, it was incandescent with the coloured candles spring-clipped to its branch tips.

When Dad lit them, and tiny spurts of yellow flame shone brightly amongst the dark green boughs, the flames were reflected in our young eyes, bright with the wonder of it all.

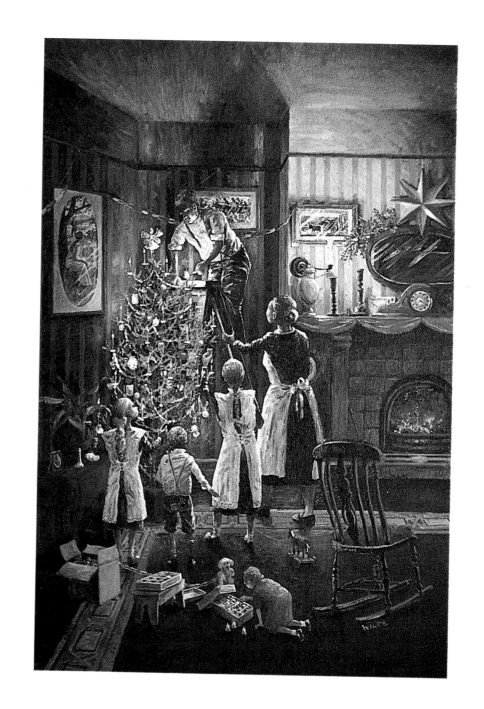

Some Milltown terms

carder: a mill operative whose job it is to comb the cotton staples so that they are parallel, ready for the spinner

cop: a cone onto which the thread is wound

degging-can: a garden watering can

doffer: a worker on spinning mules whose job is to remove cops as they fill with spun cotton

dolly-peg: a four- or six-legged stool on a long handle furnished with two arms, used to turn and agitate the clothes in the peggy-tub

duchesse set: a set of doilies for use on dressing tables

heald, or heddle: a comb-like device for lifting and lowering warp threads

ladeing-can: a straight-sided can for transferring liquids

parkin: a sticky cake made chiefly from oatmeal, treacle and ginger

peggy-stick: a short, straight stick for manipulating laundry during the boiling process

peggy-tub: a galvanized iron tub used in the wash-house

picking-peg: a device motivating the leather strap which drives the shuttle across the loom

posser: an improvement on the dolly-peg, with a brass or copper attachment with holes round the circumference

rally-o: a children's street game involving 'hunters' and 'hunted' and a sanctuary 'den'

reed: another word for warp, the longitudinal thread in weaving

reed-hook: a hook used to 'pull in' broken threads

rip-rap: a jumping firework that keeps exploding

rubbing board: a corrugated board on which clothes are scrubbed

set-boiler: a cast-iron boiler shaped like an inverted bee-hive, set in a brick surround, with a fire-flue

six-loom weaver: a highly skilled weaver

spinner: a mill operative whose job it is to produce cotton threads ready for weaving

tackler: a resourceful operative whose job is to do running repairs to looms that break down